Land of DARK, Land of LIGHT

THE ARCTIC NATIONAL WILDLIFE REFUGE

Karen Pandell ▪ *photographs by* **Fred Bruemmer**

DUTTON CHILDREN'S BOOKS NEW YORK

Library of Congress Cataloging-in-Publication Data
Pandell, Karen.
Land of dark, land of light: the Arctic National Wildlife Refuge /
by Karen Pandell; photographs by Fred Bruemmer.
—1st ed. p. cm.
Summary: Text and photographs present the animals
and plants of the Arctic throughout a year. ISBN 0-525-45094-7
1. Natural history—Alaska—Arctic National Wildlife Refuge—Juvenile literature.
2. Natural history—Alaska—Arctic National Wildlife Refuge—Pictorial works—Juvenile
literature. 3. Zoology—Alaska—Arctic National Wildlife Refuge—Juvenile literature.
4. Zoology—Alaska—Arctic National Wildlife Refuge—Pictorial works—Juvenile
literature. [1. Natural history—Arctic regions. 2. Zoology—Arctic regions.
3. Arctic regions. 4. Arctic National Wildlife Refuge (Alaska)]
I. Bruemmer, Fred, ill. II. Title. QH105.A4P36 1993
508.798—dc20 92-40405 CIP AC

Published in the United States 1993 by Dutton Children's Books,
a division of Penguin Books USA Inc.
375 Hudson Street, New York, New York 10014
Designed by Adrian Leichter
Printed in Hong Kong
FIRST EDITION
1 3 5 7 9 10 8 6 4 2

*To Rob, who was with me every step of the way
during the writing of this book; to Olaus and Margaret Murie,
whose vision helped to create the Arctic National Wildlife Refuge;
and to all the animals who live in this magnificent land*

K.P.

To Maud

F.B.

In the far north in winter, the moon shines night and day on the vast, dark land. Then one day, the sun returns, bringing light back to the Arctic. At first, the days are short. Spring is many long, cold months away.

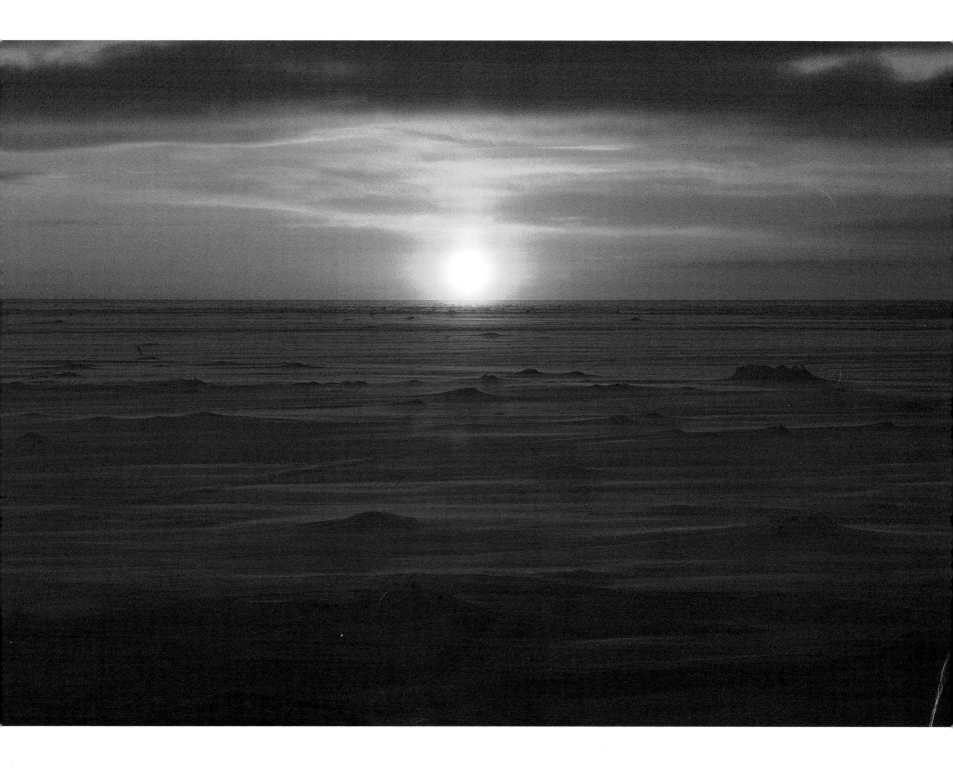

Polar bears wander across the frozen sea.

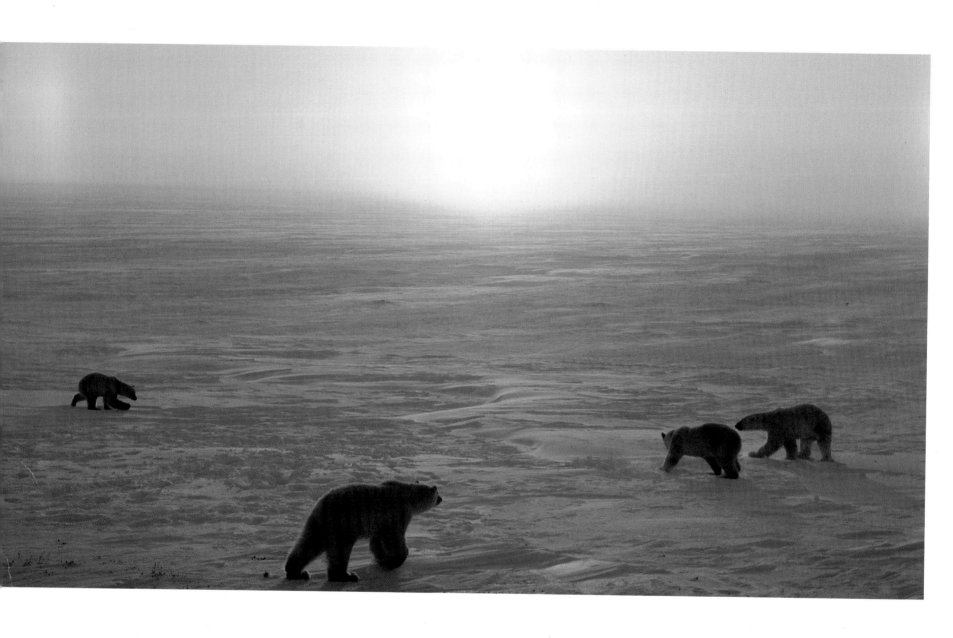

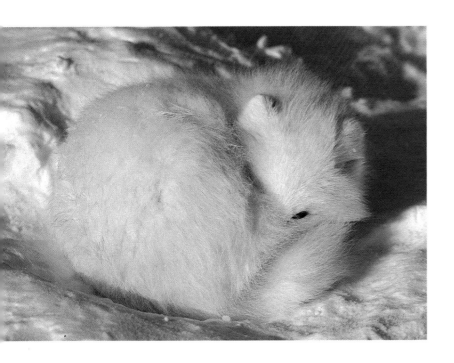

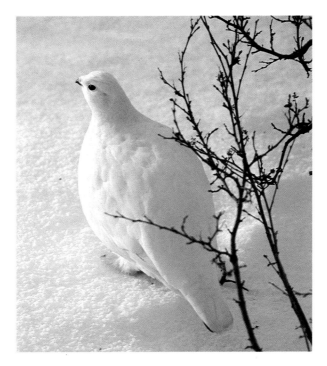

A fox sleeps snugly in its warm winter coat. A ptarmigan in white winter plumage pauses in its search for food.

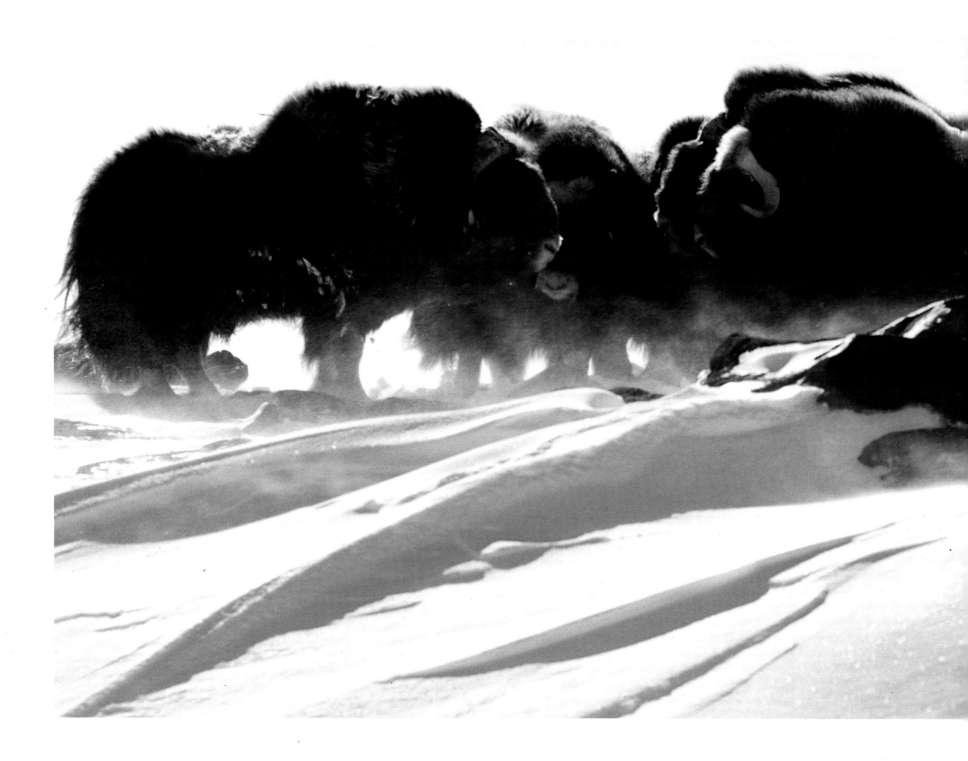

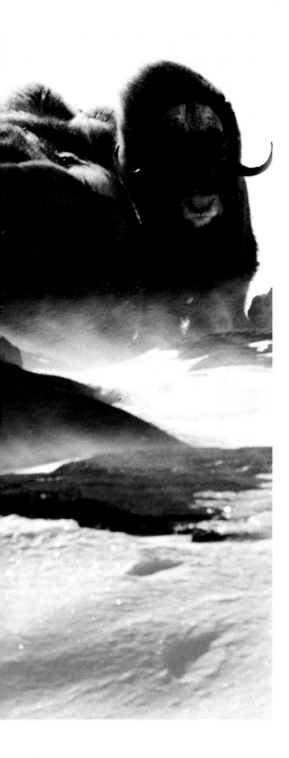

Musk-oxen form a protective circle around their young. They huddle close together in the bitter arctic wind.

As the sunlight grows stronger, the ground slowly warms. Suddenly the ice on land and sea begins to break up with loud snaps.

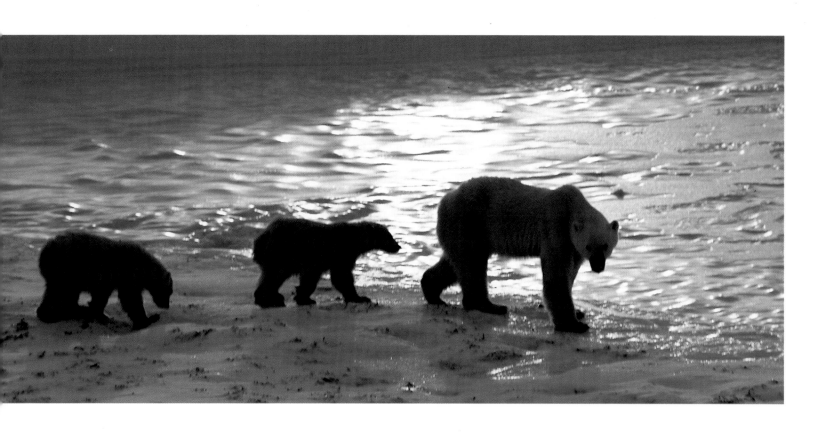

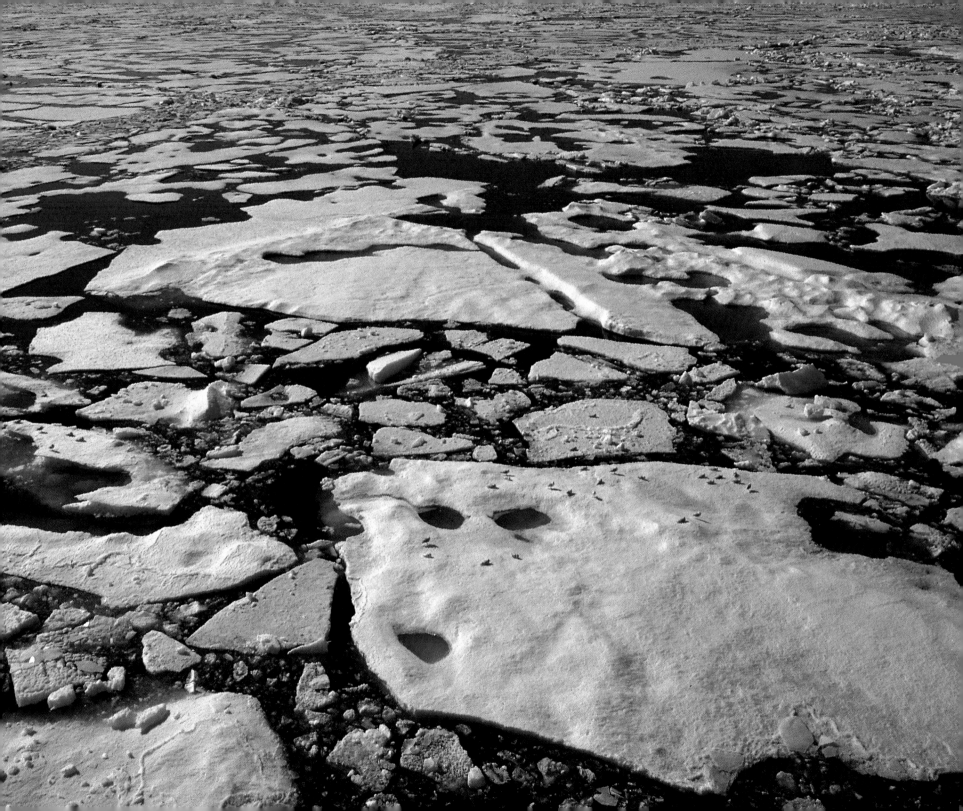

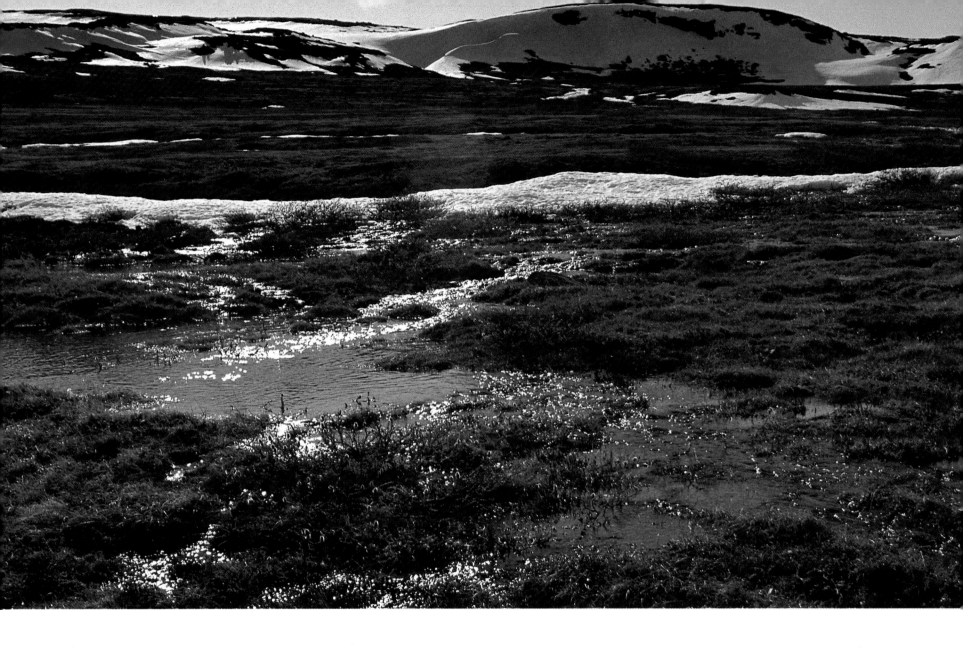

Streams of meltwater flow on the ground. After nearly six months of winter, at last it is spring.

The first arctic flowers appear—purple saxifrage, buttercups, and pasqueflowers.

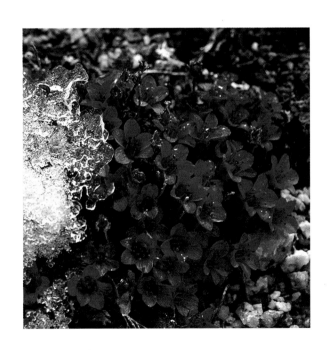 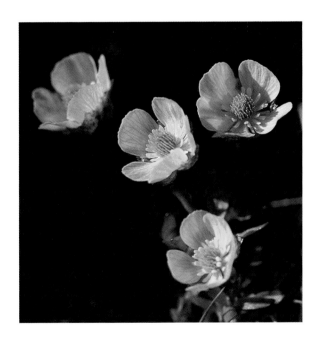 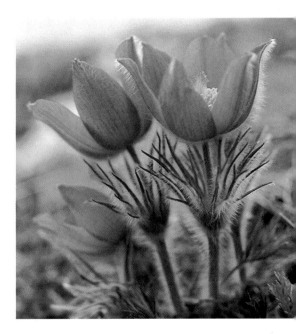

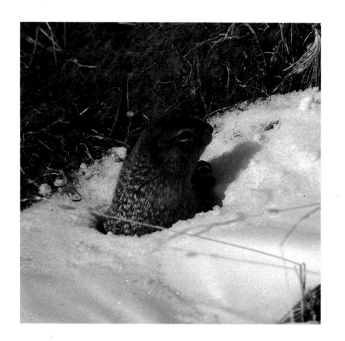 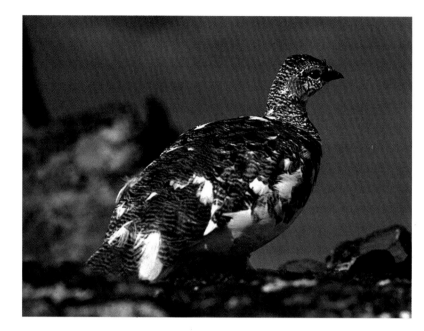

A ground squirrel wakes up and peeks out of its burrow.
The ptarmigan's feathers begin to turn brown again.

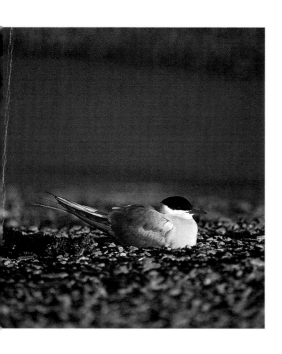

The first animal visitors, like this tern from Antarctica, begin to arrive from faraway places. Now, as in thousands of springs past, more and more birds fly in from the south and begin making their nests.

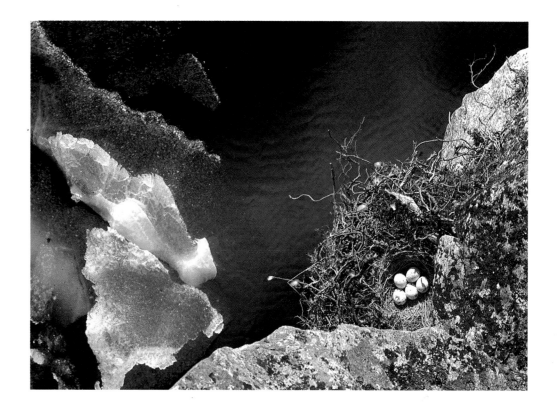

Tens of birds...hundreds of birds...thousands of birds settle upon the tundra to raise their young.

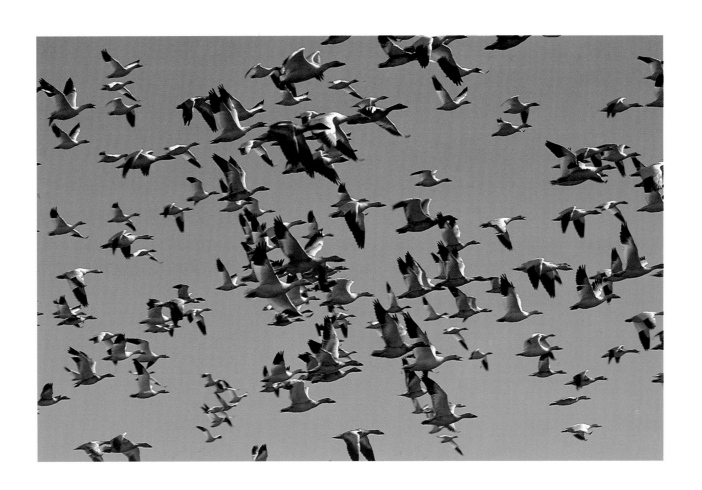

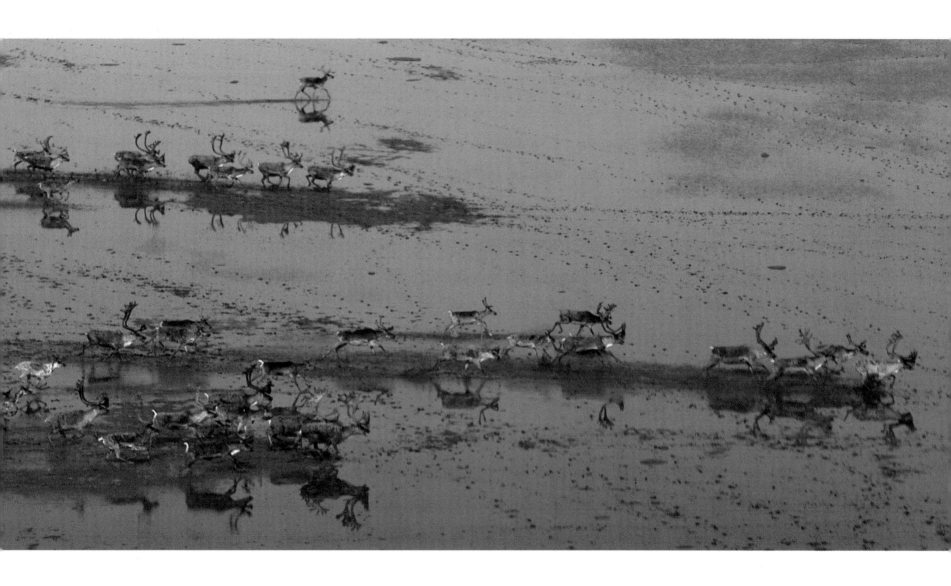

Now, as in thousands of springs past, a long line of caribou forms on the horizon. Tens of caribou . . . hundreds of caribou . . .

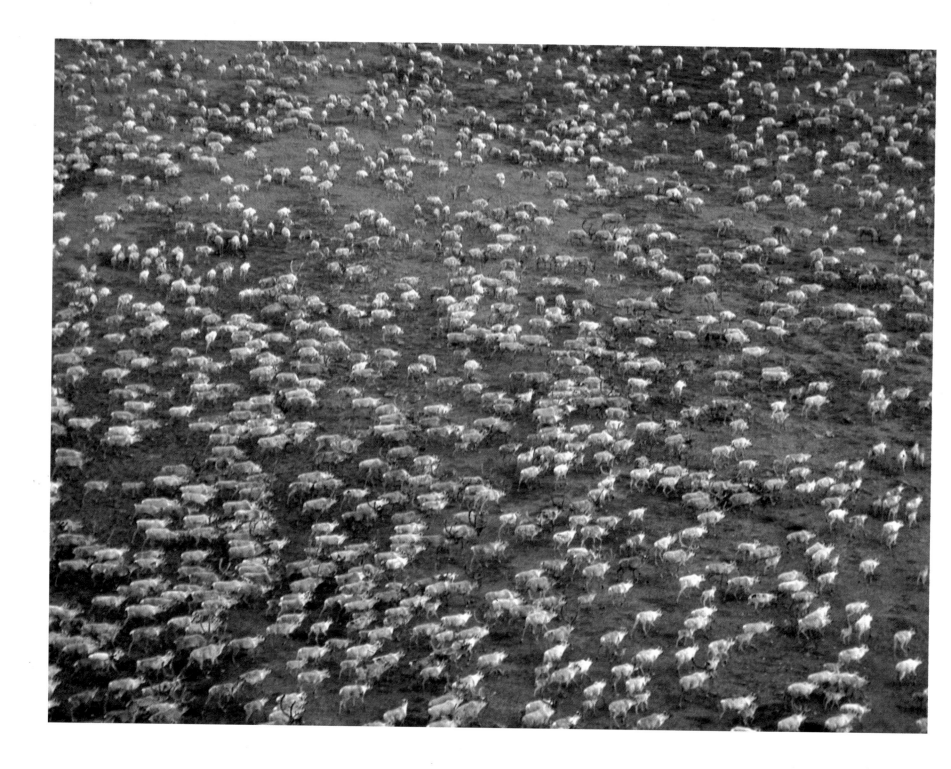

thousands of caribou follow their ancient path, giving birth to new calves on the Arctic Slope. With summer fast approaching, daylight lasts longer and longer.

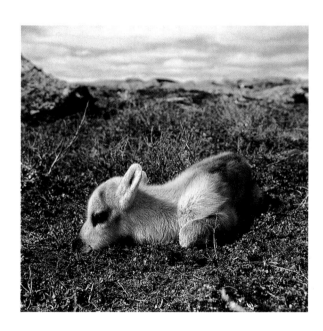

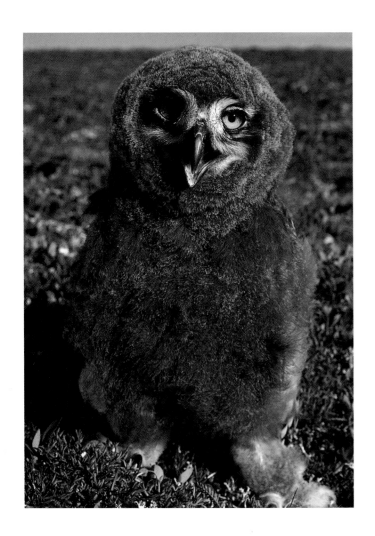

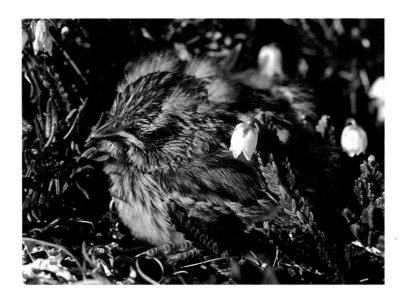

A hungry snowy owlet waits to be fed. Tiny tundra flowers, as small as a baby's fingernail, wave in the breeze.

When nights are as light as days, summer has arrived.

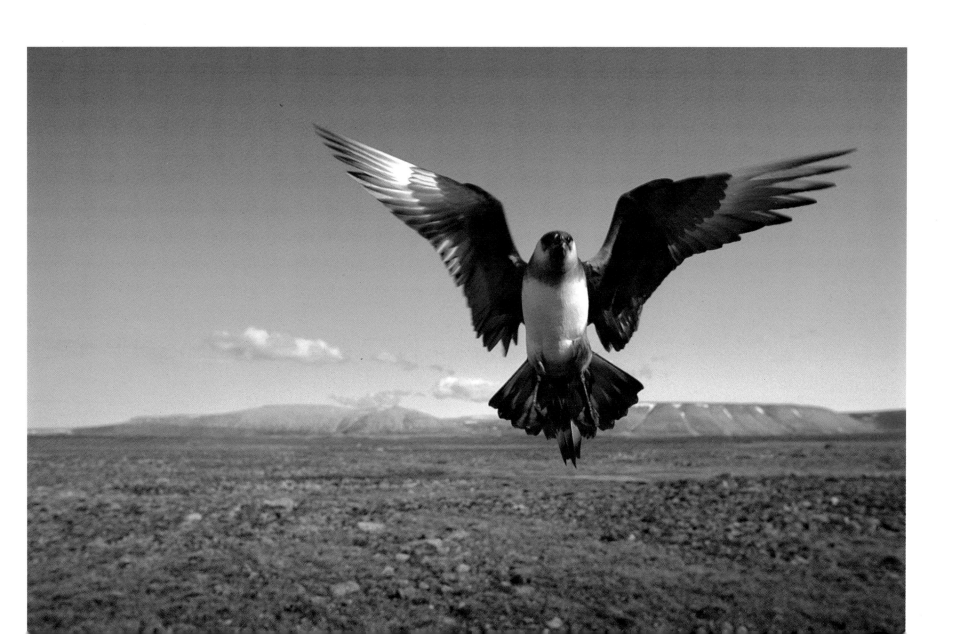

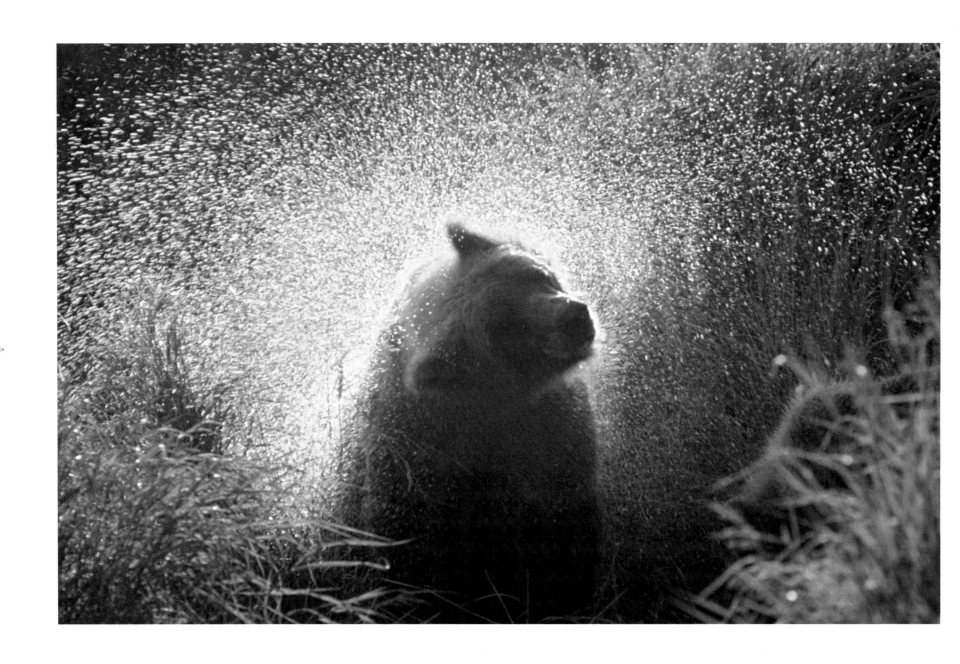

The Arctic explodes with life!

Millions of mosquitoes swarm in the air, landing on every animal that stops to rest.

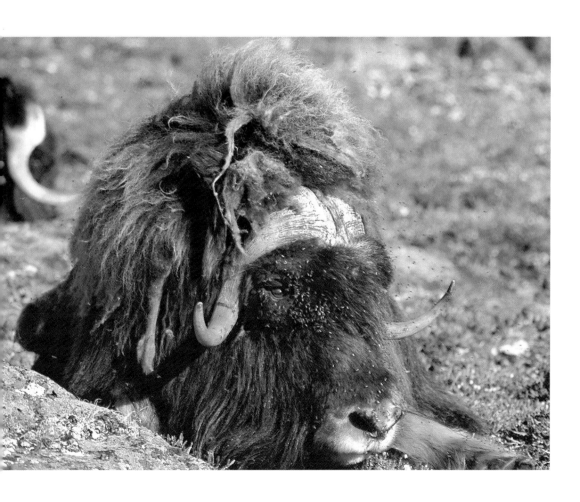

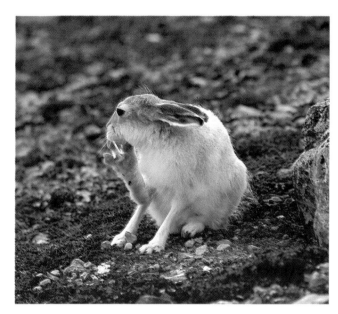

Polygon-shaped mirrors of water flash in the sun.

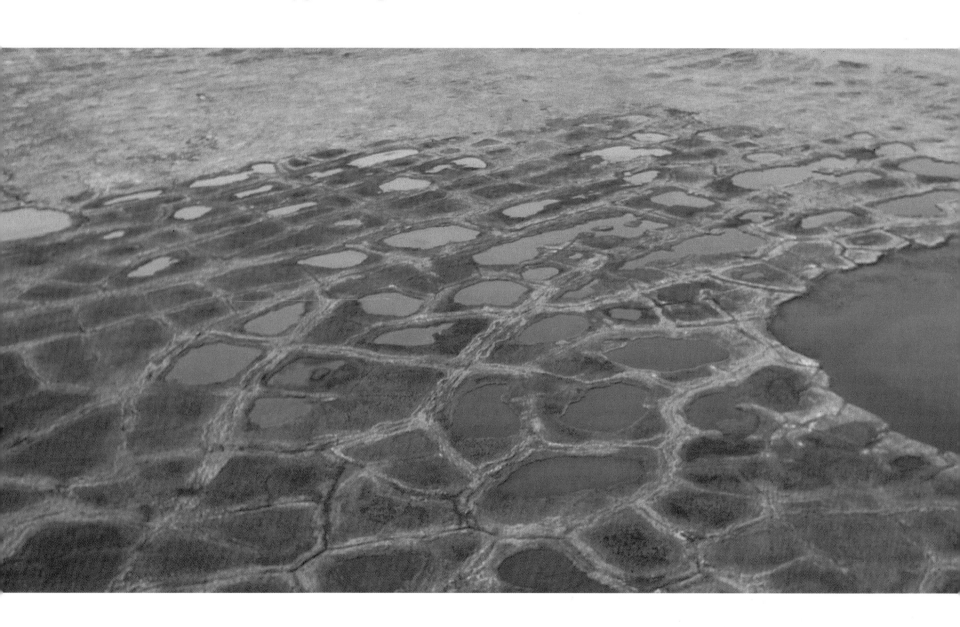

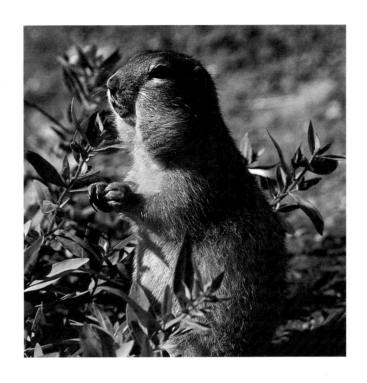

But very soon, the chill of fall is in the air. In the fading light of late summer, some animals begin to gather food for the winter.

Others prepare to migrate to winter homes in other places. A sandpiper at the edge of a tundra pond feeds one last time before flying south.

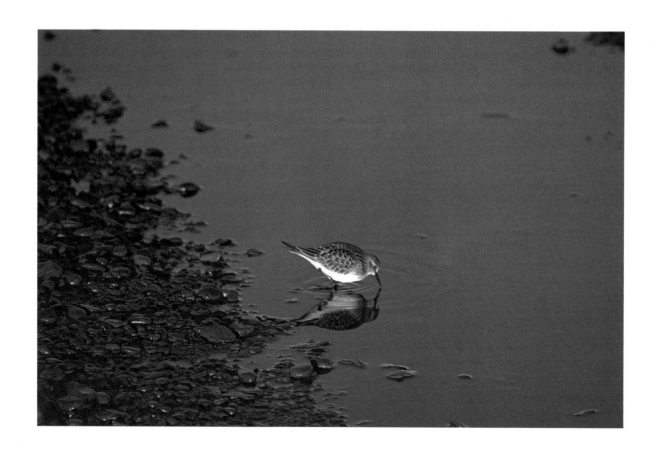

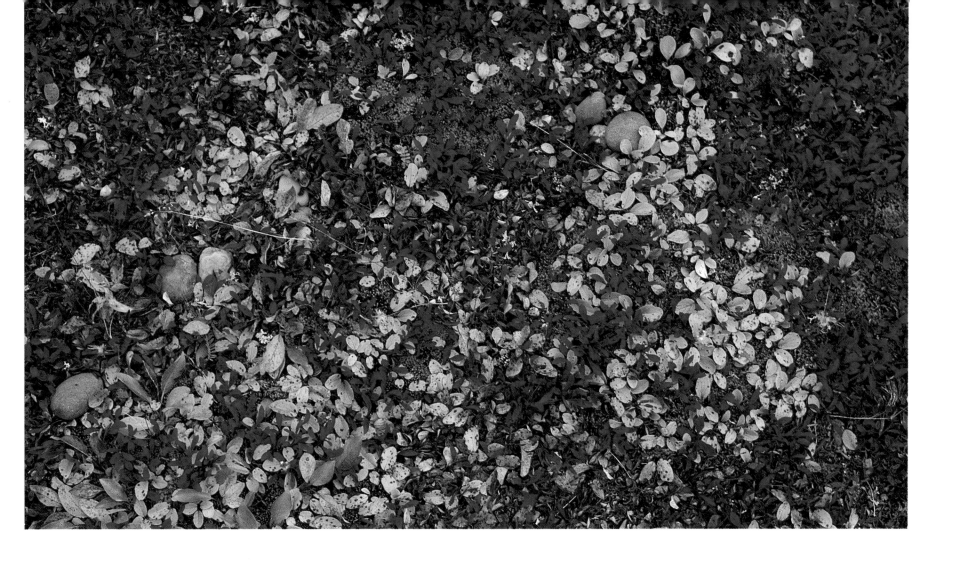

In autumn, the land is yellow and red. But after just a few weeks of this brilliant fall color, the first snow will dust the tops of hills and mountains. The long, dark winter will begin once again.

Seen from afar, in this land of vast expanses, even big animals are only dots on the landscape. Yet each and every creature, from the tiniest insect to the largest bear, plays its part in this land of dark, land of light.

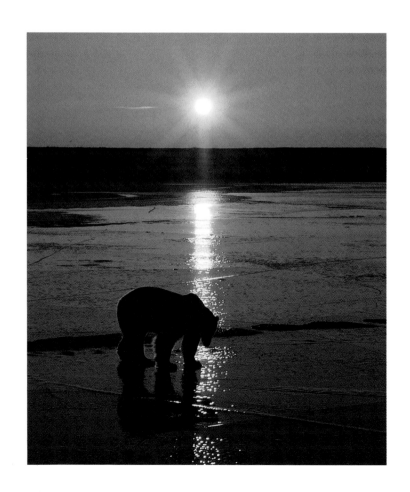

Notes on Some Animals That Live in the Arctic National Wildlife Refuge

Bear, grizzly *(Ursus arctos)*

Most adult grizzlies weigh between 350 and 700 pounds. However, a grizzly cub weighs only 1 pound when it is born! Grizzly bear mothers can be very aggressive if they suspect their cubs are being threatened. Young grizzlies are playful and curious. At times they seem to jump for joy in the wide open spaces of the tundra.

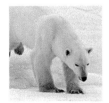

Bear, polar *(Ursus maritimus)*

The scientific name for this animal means "sea bear." Its white or cream-colored coat allows it to blend in with ice floes in the sea during summer and with snow during winter. Most North American bears sleep by day and move by night. However, polar bears can be seen on both long summer days and long winter nights. Little polar bear cubs weigh less than 2 pounds when they are born, yet will grow up to weigh between 660 and 1,300 pounds.

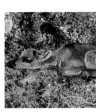

Caribou *(Rangifer tarandus)*

The spring and fall migrations of caribou between Canada and Alaska are spectacular because of the sheer number of animals traveling together in a herd. The Porcupine caribou herd, which visits the Arctic National Wildlife Refuge every spring, has about 180,000 animals in it. A caribou calf weighs 11 pounds at birth. It is well developed and can stand by itself in about thirty minutes. In only ninety minutes, it can run short distances. And within twenty-four hours, it can keep up with the herd.

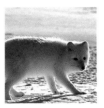

Fox, arctic *(Alopex lagopus)*

The arctic fox changes its coat from brown or gray to white for the winter. It is very adaptable and sly in its eating habits. In winter, it follows other animals to feast on or steal from their kills. In summer, it eats birds, eggs, berries, and small animals.

Goose, snow *(Chen caerulescens)*

These beautiful white geese have black wing tips. They are one of the many birds that come to the Arctic each summer to nest.

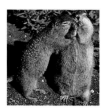

Ground squirrel, arctic *(Spermophilus parryii)*

Arctic ground squirrels are born in late June. By summer's end, they can dig their own burrows. The burrows have many tunnels and entrances. Ground squirrels live in colonies and use their burrows for many years. They also love the sun. From time to time during the day, they stop to sunbathe and swim. Ground squirrels hibernate for more than half the year.

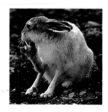

Hare, arctic *(Lepus arcticus)*

Arctic hares are the largest hares in North America. They are well adapted to stay in the Arctic all year. Their furry hind feet act like snowshoes and let them hop easily across the snow. Their short ears help to reduce the risk of frostbite in the bitter, subzero temperatures. Arctic hares change color with the seasons. In summer they are grayish brown. In winter they turn white.

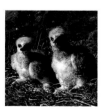

Hawk, rough-legged *(Buteo lagopus)*

Rough-legged hawks have 48- to 54-inch wingspans. They breed in the Arctic on cliffs in areas of high elevation.

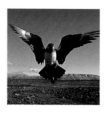

Jaeger, parasitic *(Stercorarius parasiticus)*

Parasitic jaegers (YAY-gers) look like gulls. However, they fly and dive like falcons. Their name comes from the German word *Jäger,* which means "hunter." Jaegers hunt other birds and lemmings in the Arctic.

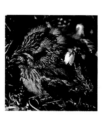

Longspur, Lapland *(Calcarius lapponicus)*

These are common tundra birds. They walk rather than hop like other finches do. Their song brings music to the Arctic.

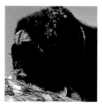

Musk-ox *(Ovibos moschatus)*

Musk-oxen look like Ice Age animals with their woolly coats and gracefully curved horns. They are fairly peaceful, but if attacked, they will form a ring around their young to guard them. The adult animals face outward from this circle and ready their horns against any predator who comes near.

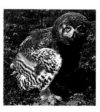

Owl, snowy *(Nyctea scandiaca)*

Snowy owls are one of the few birds to remain in the Arctic all year. As adults, these large owls are white and have 55-inch wingspans. Snowy owlets hatch in moss- or grass-lined nests made on dry ground in the tundra.

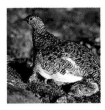

Ptarmigan, willow *(Lagopus lagopus)*

Ptarmigan (TAR-mi-gen), which change color with the seasons, are well-loved in the region. In 1955, schoolchildren chose this comical bird to be Alaska's emblem, and it is now Alaska's state bird. Ptarmigan summer on the Arctic coast. In fall, some move to inland Arctic areas, where they remain all winter. Others migrate south to various parts of Alaska and Canada.

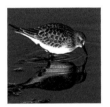

Sandpiper, Baird's *(Calidris bairdii)*

Baird's sandpiper is one species of small shorebirds that bird-watchers affectionately call "peeps." After nesting on the tundra, this little bird makes a remarkable journey. It is thought to fly nonstop for 4,000 miles during its migration!

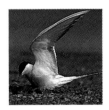

Tern, arctic *(Sterna paradisaea)*

Although arctic terns are small, they fiercely defend their young. Their wings are sleek and well adapted for long-distance flying. Each year they take one of the most fantastic voyages in the animal kingdom. After spending the summer in the Arctic, they fly all the way to Antarctica.

Environmental Note on the Arctic National Wildlife Refuge

*The Arctic National Wildlife Refuge (ANWR) is not yet fully
protected by law from destructive human activities such as oil exploration.
Until this happens, the ANWR animals need our help! The following groups
are among those working to save the ANWR and its inhabitants:*

ALASKA FRIENDS OF THE EARTH
326 W. 11th Avenue
Anchorage, Alaska 99501

GWICH'IN STEERING COMMITTEE
P.O. Box 202768
Anchorage, Alaska 99520

NATIONAL AUDUBON SOCIETY
Alaska Regional Office
308 G Street
Suite 217
Anchorage, Alaska 99501

NATURAL RESOURCES DEFENSE COUNCIL
40 West 20th Street
New York, New York 10011

NORTHERN ALASKA
ENVIRONMENTAL CENTER
Arctic National Wildlife Refuge Project
218 Driveway
Fairbanks, Alaska 99701